PRESENTED TO

FROM

DATE

Poems
for a
Friend

KIND THOUGHTS

WATERCOLORS BY
JO ANNA POEHLMANN

808.81
Poe

IDEALS PUBLICATIONS, A DIVISION OF GUIDEPOSTS
NASHVILLE, TENNESSEE
WWW.IDEALSPUBLICATIONS.COM

125430

ISBN 0-8249-4194-2

Printed and bound by R. R. Donnelly & Sons in Mexico.

Published by Ideals Publications, a division of Guideposts
535 Metroplex Drive, Suite 250
Nashville, Tennessee 37211

Library of Congress Cataloging-in-Publication Data
Poems for a Friend: kind thoughts / [Elizabeth Bonner Kea, editor];
illustrated by Jo Anna Poehlmann
 p. cm.
 ISBN 0-8249-4194-2 (alk. paper)
 1. Friendship—Poetry. 2. Friendship—Quotations, maxims, etc.
I. Kea, Elizabeth, 1976– II. Poehlmann, Jo Anna, ill.
PN6110.F8 P64 2000
808.81 '9353—dc21 00-035019

10 8 6 4 2 1 3 5 7 9

POEMS SELECTED BY ELIZABETH BONNER KEA
DESIGNED BY EVE DEGRIE

ACKNOWLEDGMENTS

JAQUES, EDNA. "Lifelong Friends" from *Fireside Poems* by Edna Jaques. Published in Canada by Thomas
Allen & Son Limited. STRONG, PATIENCE. "Time Sifts Our Friendships." Reprinted with the permission of
Rupert Crew Limited. Our sincere thanks to the following authors whom we were unable to locate:
Henry Cuyler Bunner for "One, Two, Three," Anne Campbell for "The Gift of Friendship" and "To an
Old Friend," Frances Frederick for "My Friend," Charlotte Conkright Kinney for "Song for Friendship,"
Pat Lassen for "The Heart of a Friend," James J. Metcalfe for "Another Friend," and Wilbur D. Nesbit
for "A Friend or Two."

Contents

FRIENDSHIP

FRIENDSHIP

Oh, the comfort — the inexpressible comfort
Of feeling safe with a person,
Having neither to weigh thoughts,
Nor measure words but pouring them
All right out — just as they are,
Chaff and grain together —
Certain that a faithful hand will
Take and sift them,
Keep what is worth keeping
And with the breath of kindness
Blow the rest away.

— DINAH MARIA MULOCK CRAIK

FRIENDS

If you had all the lands and gold
 It's possible for man to hold,
And if on top of that could claim
 The greatest sum of earthly fame,

Yet had to live from day to day
 Where never human came your way,
You'd trade the gold you had to spend
 To hear the greeting of a friend.

What joy can come from splendid deeds
 That no one ever cheers or heeds?
Fame would be empty and absurd
 If of it no one ever heard.

The richest man, without a friend,
 Is poor with all he has to spend.
Alone, with all that could be had,
 Each one of us would still be sad.

Not in ourselves does fortune lie,
 Nor in the things that gold can buy;
The words of praise that please so well
 The lips of other men must tell.

And honor, on which joy depends,
 Is but the verdict of our friends.
All happiness that man can know
 The friends about him must bestow.

–AUTHOR UNKNOWN

THAT'S A FRIEND

One whose grip is a little tighter,
One whose smile is a little brighter,
One whose deeds are a little whiter,
 That's what I call a friend.

One who'll lend as quick as he'll borrow,
One who's the same today as tomorrow,
One who'll share your joy and sorrow,
 That's what I call a friend.

One whose thoughts are a little cleaner,
One whose mind is a little keener,
One who avoids those things that are meaner,
 That's what I call a friend.

One, when you're gone, who'll miss you sadly,
One who'll welcome you back again gladly,
One who, though angered, will not speak madly,
 That's what I call a friend.

One who is always willing to aid you,
One whose advice has always paid you,
One who defended when others flayed you,
 That's what I call a friend.

One who was fine when life seemed rotten,
One whose ideals you have not forgotten,
One who has given you more than he's gotten,
 That's what I call a friend.

—JOHN BURROUGHS

KEY TO FRIENDSHIP

The real key to friendship
Is a tender, gentle blend
Of this plain and simple truth—
That one must be a friend.

Friendship is based upon
What we give, not what we take,
And it steers its kindly course
For a special friend's own sake.

Friendship which shall endure
And shall never crave an end
Is built upon this truth—
That one must be a friend.
—EDITH H. SHANK

THE THOUSANDTH MAN

One man in a thousand, Solomon says,
Will stick more closely than a brother.
And it's worthwhile seeking him half your days
If you find him before the other.
Nine hundred and ninety-nine depend
On what the world sees in you,
But the Thousandth Man will stand your friend
With the whole round world against you.

'Tis neither promise nor prayer nor show
Will settle the finding for thee.
Nine hundred and ninety-nine of 'em go
By your looks, or your acts, or your glory,

But if he finds you and you find him,
The rest of the world don't matter;
For the Thousandth Man will sink or swim
With you in any water.

You can use his purse with no more talk
Than he uses yours for his spendings,
And laugh and meet in your daily walk
 As though there had been no lendings.
 Nine hundred and ninety-nine of 'em call
 For silver and gold in their dealings;
 But the Thousandth Man he's worth 'em all,
 Because you can show him your feelings.
 — RUDYARD KIPLING

True Friendship

A friend is like a mighty oak
When all its leaves are gone;
A friend is like a single note
When other birds have flown.

A friend is like the broad expanse
Of shady summer green;
A friend is like the autumn bronze
That lends a later sheen.

A friend is like an evening song
Heard in the twilight hush;
A friend is one who says, "Come in,"
When others seem to rush.

For friendship true no season knows
And oft ignores the clock;
It lends a hand to strangers
And stretches round the block.

—JUNE MASTERS BACHER

POEMS FOR A FRIEND

INVITATION TO A FRIEND

Knock quietly for entrance to my heart.
The years have left a weather-beaten door;
The latch is a bit stubborn, the frame tight,
But I have kept the glass panes clear and bright.
And once inside, a fire is burning near
Two cosy chairs, a handy stool, and books.
I'll make some tea in Mama's blue teacups,
With homemade bread and butter to serve up.
No need to storm or rush or make a show;
Knock quietly, my friend; my heart will know.

—CAROL BESSENT HAYMAN

FRIENDSHIP

Friendship needs no studied phrases,
Polished face, or winning wiles;
Friendship deals no lavish praises,
Friendship dons no surface smiles.

Friendship follows nature's diction,
Shuns the blandishments of art,
Boldly severs truth from fiction,
Speaks the language of the heart.

Friendship favors no condition,
Scorns a narrow-minded creed,
Lovingly fulfills its mission,
Be it word or be it deed.

Friendship cheers the faint and weary,
Makes the timid spirit brave,
Warns the erring, lights the dreary,
Smooths the passage to the grave.

Friendship—pure, unselfish friendship,
All through life's allotted span,
Nurtures, strengthens, widens, lengthens,
Man's relationship with man.

—AUTHOR UNKNOWN

When You Know a Fellow

When you get to know a fellow,
 Know his joys and know his cares,
When you've come to understand him
 And the burdens that he bears,
When you've learned the fight he's making
 And the troubles in his way,
Then you find that he is different
 Than you thought him yesterday.

You find his faults are trivial
 And there's not so much to blame
In the brother that you jeered at
 When you only knew his name.
You are quick to see the blemish
 In the distant neighbor's style;
You can point to all his errors
 And may sneer at him the while.

When you get to know a fellow,
 Know his every mood and whim,
You begin to find the texture
 Of the splendid side of him.
You begin to understand him,
 And you cease to scoff and sneer;
For with understanding always
 Prejudices disappear.

You begin to find his virtues,
 And his faults you cease to tell;
For you seldom hate a fellow
 When you know him very well.
When you get to know a fellow
 And you understand his ways,
Then his faults won't really matter,
 For you'll find a lot to praise.

— EDGAR A. GUEST

BEING A FRIEND

I love you not only for what you are,
But for what I am when I am with you.

I love you not only for what you have made of yourself,
But for what you are making of me.

I love you because you have done more than any creed could
 have done to make me good,
And more than any fate could have done to make me happy.

You have done it without a touch, without a word,
 without a sign.
You have done it by being yourself.
Perhaps that is what being a friend means, after all.

—AUTHOR UNKNOWN

THE GIFT OF FRIENDSHIP

My friend came home from far away,
And brought a gift to me,
But in my hand no bauble lay,
And there was nothing I could see.

She gave to me a cheering word,
A happy smile, a loving glance;
And in my heart new courage stirred
To conquer changing circumstance.

There is no gift that can be bought,
Or any work of art,
As precious as the one she brought:
The beauty of a friendly heart.
— ANNE CAMPBELL

LIFELONG
FRIENDS

To an Old Friend

Out of the sunny past you came,
Calling me by my childhood name,
Bringing me meadows rich with wheat,
The sheltered lane and the cool retreat.
Out of the land of Used-to-Be,
Smiling, you gave your hand to me.
Under your spell I saw once more
The garden gate and the farmhouse door.

Once in a distant glowing time,
Shoulder to shoulder we used to climb.
Green was the hill and the path curved high
To the turquoise arch of the friendly sky.
Gone is the farmhouse and gone the grove;
Gone are the landmarks we used to love;
Gone is our footprint on the hill.
Only our friendship lingers still!

— ANNE CAMPBELL

EARLY FRIENDSHIPS

Our early friendships never fade,
 Nor do they split from wear.
The threads from which these bonds are made
 Are memories we share.

Those memories contain a strength
 Akin to strength of youth
That, as the years increase in length,
 Intensifies this truth.

Much sharper to the aging eye
 Are trials a long time spent.
Much clearer are the days gone by,
 With laughter lightly lent,

Than what is going on right now
 When problems posed are real,

And time's too hurried to allow
 The furrowed brow to feel.

We may not meet or clasp the hand
 Or even ply the pen,
But still we're sure folks understand
 Who knew us way back when

Because there pulls a tighter tie
 To old friends than to new;
And they'll agree and tell you why:
 They share those memories too.

— MARGARET RORKE

LIFELONG FRIENDS

LIFELONG FRIENDS

Lifelong friends—what lovelier thing
Could the hand of life bestow
Than a friendship built upon
All the precious things you know:
Faith in each other and the ties
Of understanding, old and wise.

A friendship flavored by the past,
Old swimming holes and days shot through
With loafin', fishin', catching crabs,
The crazy things that small kids do,
A hide-out in the woods somewhere,
Adventure on the bill of fare.

School days and hockey, bikes and skates,
A boy's face tangled in your heart,

Your first small job that in some way
Became the groundwork of your start,
The glamour of a high school dance
That seemed all beauty and romance.

These are the ties, the little things
That add up to the kindly sum
Of all that makes the days worthwhile,
The precious memories that become
As strong as hempen rope to bear
The strands of friendship woven there.

Earth holds no greater good, I think,
Than friendship welded link by link.
—EDNA JAQUES

SISTERS

For there is no friend like a sister
In calm or stormy weather;
To cheer one on the tedious way,
To fetch one if one goes astray,
To lift one if one totters down,
To strengthen whilst one stands.

—CHRISTINA ROSSETTI

One, Two, Three

It was an old, old, old, old lady
And a boy that was half past three;
And the way that they played together
Was beautiful to see.

She couldn't go romping and jumping,
 And the boy no more could he;
 For he was a thin little fellow,
 With a thin little twisted knee.

 They sat in the yellow sunlight,
 Out under the maple tree;
And the game they played I'll tell you,
 Just as it was told to me.

It was hide-and-go-seek they were playing,
Though you'd never had known it to be —

With an old, old, old, old lady,
And a boy with a twisted knee.

The boy would bend his face down
On his little sound right knee,
And he guessed where she was hiding
In guesses One, Two, Three.

And they never had stirred from their places
Right under the maple tree—
This old, old, old, old lady,
And the boy with the lame little knee—
This dear, dear, dear, old lady
And the boy who was half past three.
— HENRY CUYLER BUNNER

CHILDHOOD FRIENDS

Remember when we were little girls
 and I lived across from you?
Remember when both of us wore long curls
 tied back with bows of blue?

Remember the days in wintertime
 when we walked together to school?
While snowdrifts covered the streets outside,
 we recited the golden rule.

Remember the days of buggies and dolls
 when we played at keeping house,
And you wore your mother's high-heeled shoes
 while I wore my Mama's blouse?

For you were my favorite, my very best friend,
 and I was your first choice, too,
And we learned of the give and take of life
 as our childhood friendship grew.

—MILDRED SPIRES JACOBS

THE JOY

OF

FRIENDSHIP

DAY WITH A FRIEND

Spring is a robin; summer's a rose;
Autumn's a pumpkin; winter's the snows.

Without appointment, they all drop in,
Never explaining where they have been.

Bringing a package of silvery gray
Or a bright ribbon of daffodil day.

Such is our friendship; I know 'tis true;
For all days are lovely when shared with you.

—JUNE MASTERS BACHER

ANOTHER FRIEND

My heart is always happy
When I truthfully can say
That by the grace of God
I made another friend today.

There is no better way
In which to use the time we spend
Than just to smile and say hello
And find another friend.

We cannot have too many
For the courage that we need
If only in the comfort of
A good and kindly deed,

If only in the counsel
And the words of sympathy
That leave no doubt or question
As to their sincerity.

And so it always is a day
That has a happy end
When I can tell myself
That I have made another friend.
—JAMES J. METCALFE

THE WORTH OF A FRIEND

Can you measure the worth of a sunbeam,
The worth of a treasured smile,
The value of love and of giving,
The things that make life worthwhile?
Can you cling to a precious minute
When at last it has ticked away?
At the end of a fleeting lifetime,
Who of us dares bid it stay?

Can you measure the worth of tomorrow,
The good that by chance might come;
The heartaches, the joys, the sorrows,
Each an important one?
Life has a way of demanding,
Right to the very end,

The prize to be sought—understanding;
That comes from the worth of a friend.

Can you measure the value of friendship,
Of knowing that someone is there,
Of faith and of hope and of courage,
A treasured and goodly share?
For nothing is higher in value,
Whatever life chooses to send—
We must prove that we too are worthy
And equal the worth of a friend.
—GARNETT ANN SCHULTZ

THE HEART OF A FRIEND

The heart of a friend is a wondrous thing,
A gift of God most fair;
For the seed of friendship there sprouts and grows
In love and beauty rare.

As the years go by, bringing joy and grief,
We long for one to share;
And that lovely garden in the heart of a friend
Proves a shelter from all care.

Yes, the heart of a friend is a wondrous thing,
A gift of God most fair;
May I carefully tend the seed which grows
In friendship's garden there.

— PAT LASSEN

CONFESSION

I've had a habit all my life,
And this I now confess,
Of placing on a pedestal
The friends that I possess.

I know that it's not practical,
I know that it's not wise,
But still I go on doing it
With stardust in my eyes.

I've had some disillusionment,
Some disappointments too;
At times the pedestal has crashed
Despite what I would do.

But I have found abundant joy,
So much that's sweet and fine;
I treasure it, unwise or not,
This habit that is mine.

— HILDA BUTLER FARR

FRIENDSHIP

I want the man I meet each day,
Wherever I may be,
To know that joy and happiness
Just radiate from me.
I want to put so much into
The handclasp I extend
That every man I meet will say,
"I know he'll be a friend."

I want to greet my fellowmen
With such a hearty smile
That it will banish all their care
And make life seem worthwhile.
I want to understand their need
And such assistance lend

That every man I know will feel,
"I'm glad he is my friend."

I ask not honor nor reward
For anything I do;
I just would open wide my heart
And let the love shine through.
Though I but meet a brother once,
 One touch, one smile I'd send
 And cause that man to sing for aye,
 "I'm glad he is my friend."
 —Francis J. Gable

POEMS FOR A FRIEND

THE ARROW AND THE SONG

I shot an arrow into the air,
It fell to earth, I knew not where;
For so swiftly it flew, the sight
Could not follow it in its flight.

I breathed a song into the air,
It fell to earth, I knew not where;
For who has sight so keen and strong,
That it can follow the flight of song?

Long, long afterward, in an oak
I found the arrow, still unbroke;
And the song, from beginning to end,
I found again in the heart of a friend.

—HENRY WADSWORTH LONGFELLOW

SONG FOR FRIENDSHIP

I love you, O friend,
 because you have given my heart a new song—
When I was discouraged, a fresh impulse to try again;
When doubtful, a new vision of truth and victorious faith;
When lonely, you invited guests—the great souls,
And made fragrant, immortal friendships.

I love you, O friend,
 because you have opened my eyes to enduring values;
Awakened my giant self—my divine self within me.
Because, in the garden of my thoughts,
You often have uprooted a thistle
And planted a hyacinth.

I love you, O friend,

 because you have inspired in me
The flaming, unquenchable desire
To rise and walk out to meet truth and beauty
Fearless and unencumbered.

—CHARLOTTE CONKRIGHT KINNEY

MY FRIEND

My friend—how blest indeed am I to know you so!
To hear your voice, to feel the warm handclasp,
To know you trust in me when others looked askance.
Ah, this were joy and peace and comfort, too.

This do I know; for often, when an unkind fate
Has left me crushed, my struggle all in vain,
Hope lost in disappointment—
Your words, "I believe in you,"
Have sent pulses leaping, rousing my wavering soul
To efforts new.

And I shall win success, at last, feeling your strength
Of good will and faith —
Knowing, though all the world may doubt,
That you will understand.

So does my heart go out in gratitude to God,
Who in His goodness, gave me this great gift —
My friend.

—FRANCES FREDERICK

A FRIEND OR TWO

There's all of pleasure and all of peace
 In a friend or two;
And all your troubles may find release
 Within a friend or two.
It's in the grip of the sleeping hand
On native soil or in alien land,
But the world is made, do you understand,
 Of a friend or two.

A song to sing and a crust to share
 With a friend or two;
A smile to give and a grief to bear
 With a friend or two;
A road to walk and a goal to win,
An inglenook to find comfort in,
The gladdest hours that we know begin
 With a friend or two.

A little laughter, perhaps some tears
　　With a friend or two;
The days, the weeks, the months and years
　　With a friend or two;
A vale to cross and a hill to climb,
A mock at age and a jeer at time,
The prose of life takes the lilt of rhyme
　　With a friend or two.

The brother-soul and the brother-heart
　　Of a friend or two
Make us drift on from the crowd apart
　　With a friend or two.
For come days happy or come days sad,
We count no hours but the ones made glad
By the hale good times we have ever had
　　With a friend or two.
—WILBUR D. NESBIT

LETTERS
FROM
FRIENDS

FRIENDSHIP'S ROAD

I've a warm and friendly feeling
 As I think of you today;
And I wish that we could visit,
 But you're many miles away.

Separated by such distance,
 Yet your letters bring you near;
Through the miles we share a friendship
 That's become to me most dear.

Friends through correspondence only;
 Still your face I need not see
For your soul shines through the pages
 Every time you write to me.

—BEVERLY J. ANDERSON

LETTERS BETWEEN FRIENDS

I've written you in thoughts, my friend,
So often through the years,
But somehow ink just couldn't find
The words to make thoughts clear.

Within my thoughts, I have relived
Those happy times we shared
As childhood friends who ran and played
Without the slightest care.

You were a friend to me back then,
And still you are today;
For memories can give us strength
And help us on our way.

In my thoughts I've thanked you, friend,
Though surely not enough,
For your example years ago
Still helps when times are rough.

I've often written in my thoughts,
But here at last are words
To say I thank you for the joys
That in my heart you've stirred.
—CRAIG E. SATHOFF

FRIENDS THROUGH CORRESPONDENCE

I have found that friends who live
One thousand miles away
Have added color to my life
Through written words each day.

They always show more interest
Than those friends along the street
Who do not know my thoughts at all
Though many times we meet.

POEMS FOR A FRIEND

I've found companionship so dear
Through looked-for envelopes
Containing inspiration of
My deepest dreams and hopes.

I would not trade this priceless gift
For anything on earth,
Because, through correspondence, I
Have found what friends are worth.
—ELSIE M. FARR

LETTERS

A few words drifting over time and space
Can bring warmth, a glow of friendliness;
A voice unheard, a loved one's absent face
Return with written words. A soft caress,
The echo of an old, forgotten song,
Between the lines, a sudden, clear reflection
To fill the heart with pleasure, deep and strong,
Brings back again a voice's dear inflection.
Across the miles, the handclasp of a friend
Reaches out within a letter's lines,
And down a little lane, dream–footsteps wind
Where memory's flowered tendril greenly twines.

From old friends come small messages we love;
Just little things that bring a bit of cheer,
And, like sun smiling through the clouds above,
Are cherished words of someone we hold dear.
Oh, letters are like angels without wings
That come to us as if on magic flight,
Can evoke tears or happiness that sings,
Bright little flames that light the darkest night.

— RUTH B. FIELD

LASTING
FRIENDSHIPS

TO A FRIEND

I ask but one thing of you, only one:
That always you will be my dream of you;
That never shall I wake to find untrue
All this I have believed and rested on,
Forever vanished, like a vision gone
Out into the night. Alas, how few
There are who strike in us a chord we knew
Existed, but so seldom heard its tone;
We tremble at the half-forgotten sound.
The world is full of rude awakenings
And heaven-born castles shattered to the ground.
Yet still our human longing vainly clings
To a belief in beauty through all wrongs,
Oh stay your hand, and leave my heart its songs!

—AMY LOWELL

A Mile with Me

Oh, who will walk a mile with me
Along life's merry way?
A comrade blithe and full of glee,
Who dares to laugh out loud and free
And let his frolic fancy play,
Like a happy child through the flowers gay
That fill the field and fringe the way
Where he walks a mile with me.

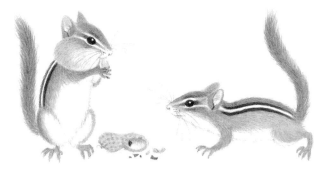

POEMS FOR A FRIEND

And who will walk a mile with me
Along life's weary way?
A friend whose heart has eyes to see
The stars shine out o'er the darkening lea
And the quiet rest at the end of the day—
A friend who knows and dares to say
The brave, sweet words that cheer the way
Where he walks a mile with me.

With such a comrade, such a friend,
I fain would walk till journey's end,
Through summer sunshine, winter rain,
And then, farewell, we shall meet again!
—HENRY VAN DYKE

To a Friend

You entered my life in a casual way
 And saw at a glance what I needed;
There were others who passed me or met me each day,
 But never a one of them heeded.
Perhaps you were thinking of other folks more,
 Or chance simply seemed to decree it.
I know there were many such chances before,
 But the others—well, they didn't see it.

You said just the thing that I wished you would say,
 And you made me believe that you meant it;
I held up my head in the old gallant way
 And resolved you should never repent it.
There are times when encouragement means such a lot
 And a word is enough to convey it;

There were others who could have, as easy as not —
 But, just the same, they didn't say it.

There may have been someone who could have done more
 To help me along, though I doubt it;
What I needed was cheering, and always before
 They had let me plod onward without it.
You helped to refashion the dream of my heart
 And made me turn eagerly to it;
There were others who might have (I question that part) —
 But, after all, they didn't do it!

— GRACE STRICKLER DAWSON

FRIENDS

If all the sorrows of this weary earth —
The pains and heartaches of humanity —
If all were gathered up and given me,
I still would have my share of wealth and worth
Who have you, Friend of Old, to be my cheer
Through life's uncertain fortunes, year by year.

Thank God for friends, who dearer grow as years increase;
Who, as possessions fail our hopes and hands,
Become the boon supreme, than gold and lands
More precious. Let all else, if must be, cease;
But Lord of Life, I pray on me bestow
The gift of friends, to share the way I go.

— THOMAS CURTIS CLARK

GATHERING UP THE THREADS

How good it is to meet old friends
And gather up the threads once more,
To reminisce of days gone by
And travel through youth's open door.
To stir some cherished memories
Long hidden deep within the heart,
Which never seem to come to life
When traveling down the years apart.
There's nothing more that is as sweet
Or helps to make the spirit soar
As meeting with some good old friends
To gather up the threads once more.

— HILDA BUTLER FARR

TIME SIFTS OUR FRIENDSHIPS

Time sifts our friendships and our friends,
For time alone can be the test;
And with the passing of the years
We lose the false and keep the best.

And when beyond the distant hills
The golden sun of life descends,
We find God's greatest gift has been
The love of true and faithful friends.

— PATIENCE STRONG

MY THANKS FOR OTHERS

O Lord, how very much I owe
To others whom you've let me know
 And see from day to day—
The young, the old, the in-between
 Who make an entrance in the scene
 In which I'm called to play.

Another's sweet approving smile
Can make my efforts seem worthwhile
 And crown my will to try.
Encouragement another speaks
Is oft the spur my spirit seeks
 Though not quite knowing why.

And, yes, I am so grateful, too
For those who hold a dimmer view
 Of me and my poor part
Because they challenge me to test
What's truly noble, pure, and best
 Within my mind and heart.

I often wonder how I'd be
Without the folks surrounding me—
 My vital, living hem.
That's why I pause to give this prayer
To You it pleased to put them there.
 I thank you, Lord, for them.
—Margaret Rorke

POEMS FOR A FRIEND

New Friends and Old Friends

Make new friends, but keep the old;
Those are silver, these are gold.
New-made friendships, like new wine,
Age will mellow and refine.
Friendships that have stood the test—
Time and change—are surely best;
Brow may wrinkle, hair may gray,
Friendship never knows decay.
For 'mid old friends, alas! may die;
New friends must their place supply.
Cherish friendship in your breast—
New is good, but old is best.
Make new friends, but keep the old;
Those are silver, these are gold.

—JOSEPH PARRY

It's Never Far

It's never far to an old friend's house,
And the way is smooth and fine;
The path bears many a telltale mark
Of footprints, his and mine.
Each hill and vale and winding curve
Its youthful fancies lend,
And miles are short when I go forth
To the house of an old, old friend.

The day is always bright and fair
When I, on a friend, do call,
Who has been a friend in time and stress
And "stood by" through it all.
Though skies are drear and clouds hang low,
And the outlook's drab and gray;
There's a radiant glow at an old friend's house
That drives the gloom away.

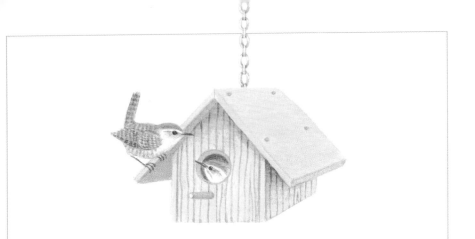

Time never drags at an old friend's house,
And the hours are filled with joy.
He pictures me, I picture him
As a carefree, laughing boy.
Old faces beam with wrinkled smiles,
And the long years brightly blend
In a wealth of treasured memories—
At the house of an old, old friend.

—ADAM N. REITER

SALT OF THE EARTH

New friends I cherish and treasure their worth,
But old friends to me are the salt of the earth.
Friends are like garments that everyone wears—
New ones are needed for dress-up affairs;
But when we're at leisure, we're more apt to choose
The clothes that we purchased with last season's shoes.

Things we grow used to are the ones we love best—
The ones we are certain have weathered the test.
And isn't it true, since we're talking of friends,
That new ones bring pleasure when everything blends?

But when we want someone who thinks as we do
And who fits, as I said, like last summer's shoe,

We turn to the friends who have stuck through the years,
Who echo our laughter and dry up our tears.
They know every weakness and fault we possess,
But somehow forget them in friendship's caress.

The story is old, yet fragrant and sweet.
I've said it before, just let me repeat:
New friends I cherish and treasure their worth,
But old friends to me are the salt of the earth.

—AUTHOR UNKNOWN

LASTING FRIENDSHIPS

THE FRIEND WHO JUST STANDS BY

When trouble comes your soul to try,
You love the friend who just "stands by."
Perhaps there's nothing he can do—
The thing is strictly up to you.
For there are troubles all your own
And paths the soul must tread alone.
Times when love can't smooth the road
Nor friendship lift its heavy load.

But just to know you have a friend
Who will "stand by" until the end,
Whose sympathy through all endures,
Whose warm handclasp is always yours—
It helps, some way, to pull you through,
Although there's nothing he can do.
And so with fervent heart you cry,
"God bless the friend who just 'stands by!'"
— B. Y. WILLIAMS

TITLE INDEX

First Line Index

Author Index